PAINT BY STICKER®
WORKS OF ART

workman
• NEW YORK •

The following works of art were used to create the low-poly interpretations in this book:

Dancers in Blue by Edgar Degas
Credit: Bridgeman Images

The Lute Player by Michelangelo Merisi, known as Caravaggio
Credit: Bridgeman Images

Woman with a Fan by Pierre-Auguste Renoir
Credit: Bridgeman Images

The Migration Series, Panel No. 57: The female workers were the last to arrive north by Jacob Lawrence
Credit: © 2023 The Jacob and Gwendolyn Knight Lawrence Foundation, Seattle/Artists Rights Society (ARS), New York. The Phillips Collection, Washington, DC, USA/Acquired 1942/Bridgeman Images.

Still Life with Fruit Dish by Paul Cézanne
Credit: Bridgeman Images

Putti, detail from *The Sistine Madonna* by Raphael
Credit: © Staatliche Kunstsammlungen Dresden/Bridgeman Images

The Starry Night by Vincent van Gogh
Credit: Bridgeman Images

The King's Sadness by Henri Matisse
Credit: © 2023 Succession H. Matisse/Artists Rights Society (ARS), New York. Digital Image © CNAC/MNAM, Dist. RMN-grand Palais/Art Resource, NY.

Portrait of Marie-Antoinette by Martin van Meytens
Credit: Bridgeman Images

Tropical Forest with Monkeys by Henri Rousseau
Credit: Bridgeman Images

The Kiss by Gustav Klimt
Credit: Bridgeman Images

Self Portrait, Dedicated to Dr. Eloesser by Frida Kahlo
Credit: © 2023 Banco de México Diego Rivera Frida Kahlo Museums Trust, Mexico, D.F./Artists Rights Society (ARS), New York. Photo © Fine Art Images/Bridgeman Images.

Library of Congress Cataloging-in-Publication Data is available.

ISBN 978-1-5235-2395-5

Design by Terri Ruffino
Art by Liam Brazier

Workman books are available at special discounts when purchased in bulk for premiums and sales promotions as well as for fundraising or educational use. Special editions or book excerpts can also be created to specification. For details, please contact special.markets@hbgusa.com.

Workman Publishing Co., Inc., a subsidiary of Hachette Book Group, Inc.
1290 Avenue of the Americas
New York, NY 10104

workman.com

WORKMAN and PAINT BY STICKER are registered trademarks of Workman Publishing Co., Inc., a subsidiary of Hachette Book Group, Inc.

Printed in China on responsibly sourced paper.
First printing October 2023

10 9 8 7 6 5 4 3 2 1

INTRODUCTION

IT'S FAIRLY SIMPLE, ACTUALLY. You could try it even now, in your mind. Imagine a sticker. Nothing fancy. Just a swatch of color in a random shape with three or four sides. You remember stickers. They're simple. They're delightful.

Okay, you're holding the sticker. It has a number by it: **D31**. That's easy to remember. **D31**. You take the sticker to the page with the corresponding image. On the page is a silhouette. Inside the silhouette is a network of delicate lines that form myriad shapes—let's call it a map. A sticker map.

All you have to do is find the shape labeled **D31**. It's over there. While you look, you might think about your day. You might take a moment to feel your own breath and relax. You place the sticker onto the space. It's as if you filled the space with a perfectly even coat of paint. You brought color to the world. It might have been the cobalt swirls of Van Gogh's *The Starry Night* or the warm mahogany browns of Caravaggio's *The Lute Player*.

It's a giddy feeling. Simple beauty. You could do it again. You could paint the whole image. It'd be yours. Don't worry if the lines are a bit off. They look like the irregular stones in a mosaic. Timeless. Simple.

GO AHEAD. YOU'RE A NATURAL.

TIPS TO GET YOU STARTED:

1. The sticker sheets are assigned to each sticker map by the thumbnail images in the top corners of the sticker sheets.

2. Use the perforations to tear out either the sticker map or the sticker sheet so you don't have to flip back and forth while working on a project.

3. Do the projects in any order you like. You're in charge.

4. Place one corner of the sticker down and adjust from there. Be careful; these stickers are not removable.

5. For precision placement, use a toothpick or tweezers.

6. After you complete an image, place a sheet of paper over it and press down with a flat object, like a ruler or bone folder, to help everything stick.

CONTENTS

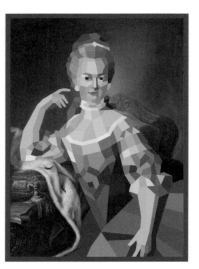

1. *Dancers in Blue* by Edgar Degas

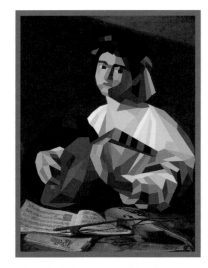

2. *The Lute Player* by Michelangelo Merisi, known as Caravaggio

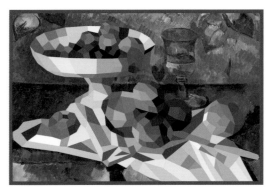

5. *Still Life with Fruit Dish* by Paul Cézanne

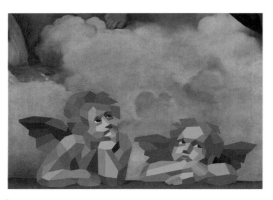

6. Putti, detail from *The Sistine Madonna* by Raphael

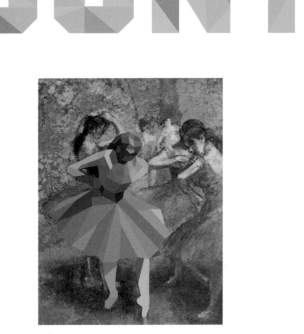

9. *Portrait of Marie-Antoinette* by Martin van Meytens

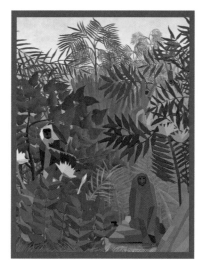

10. *Tropical Forest with Monkeys* by Henri Rousseau

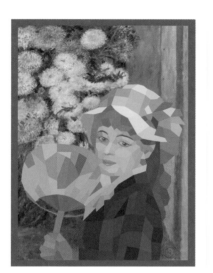

3. *Woman with a Fan* by Pierre-Auguste Renoir

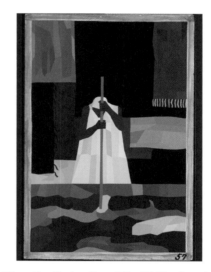

4. *The Migration Series, Panel No. 57: The female workers were the last to arrive north* by Jacob Lawrence

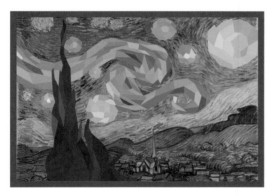

7. *The Starry Night* by Vincent van Gogh

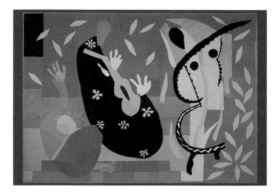

8. *The King's Sadness* by Henri Matisse

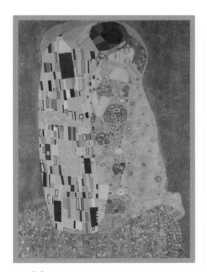

11. *The Kiss* by Gustav Klimt

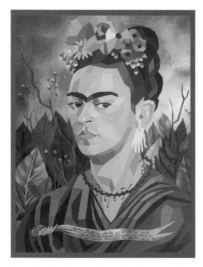

12. *Self Portrait, Dedicated to Dr. Eloesser* by Frida Kahlo

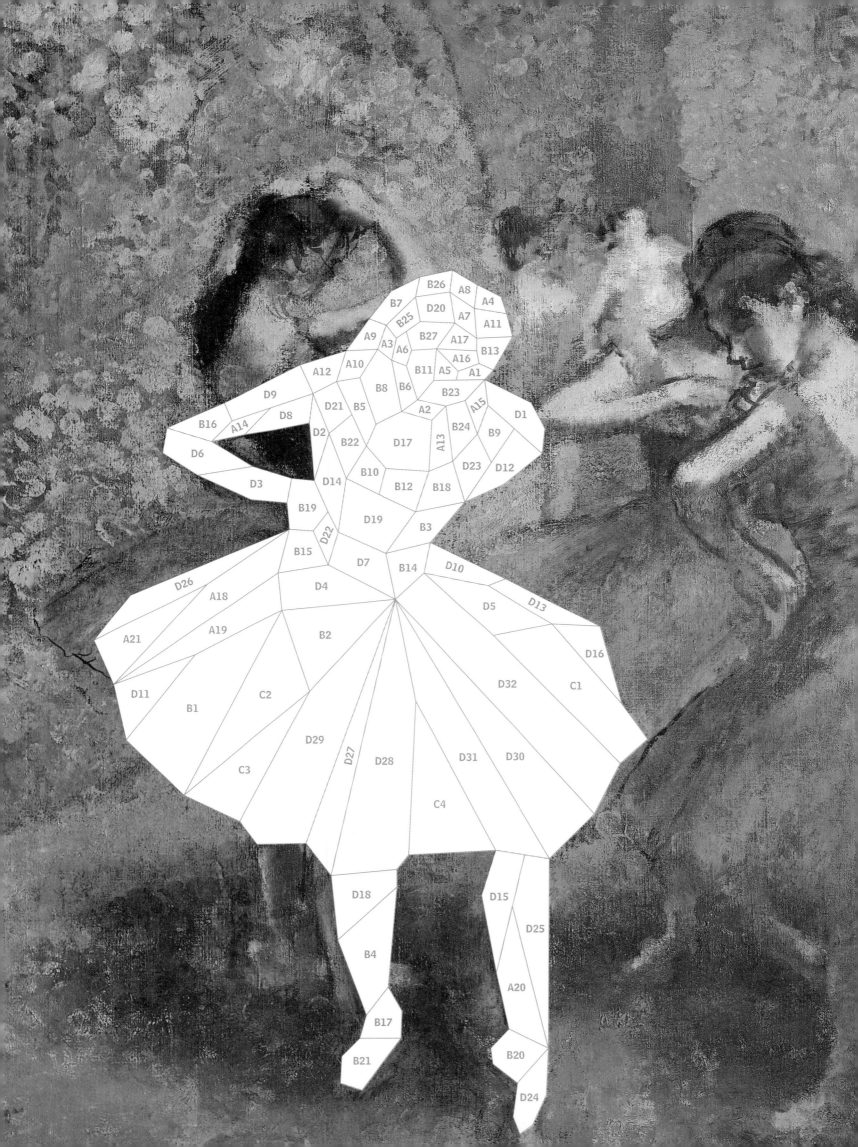

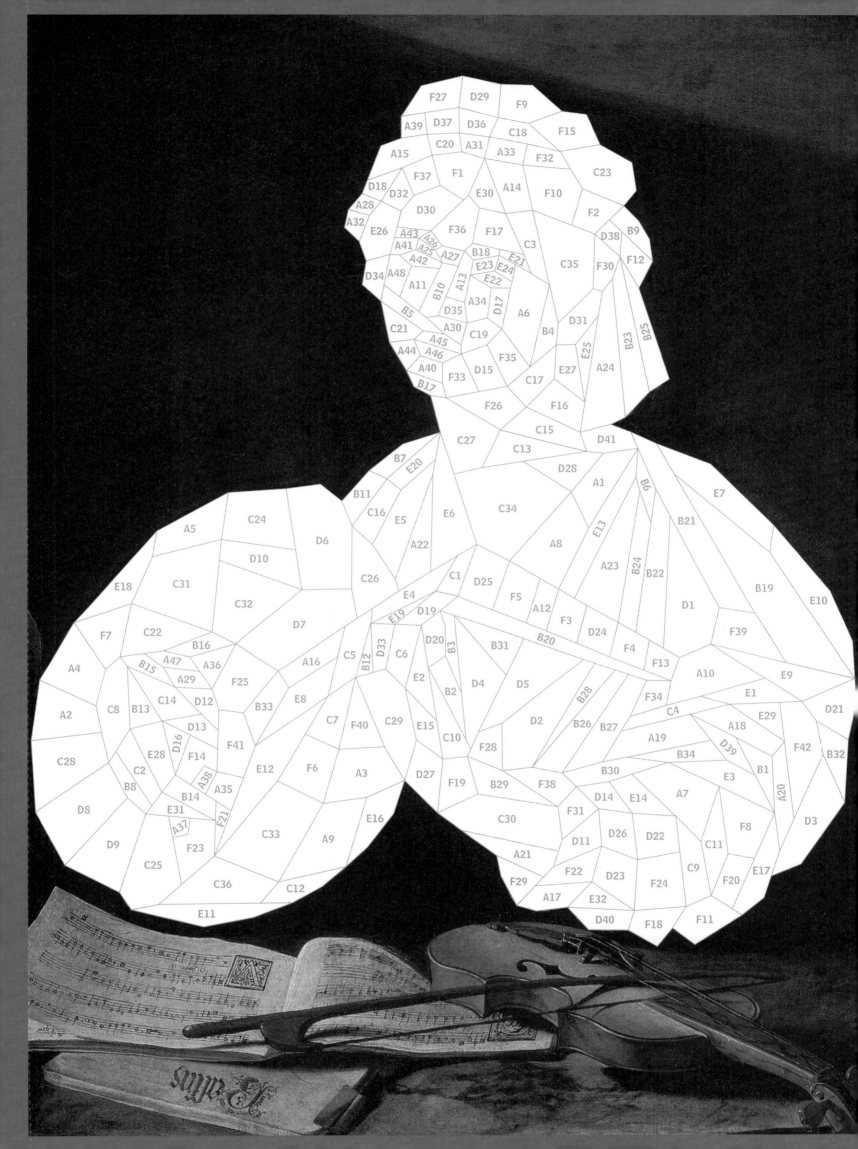

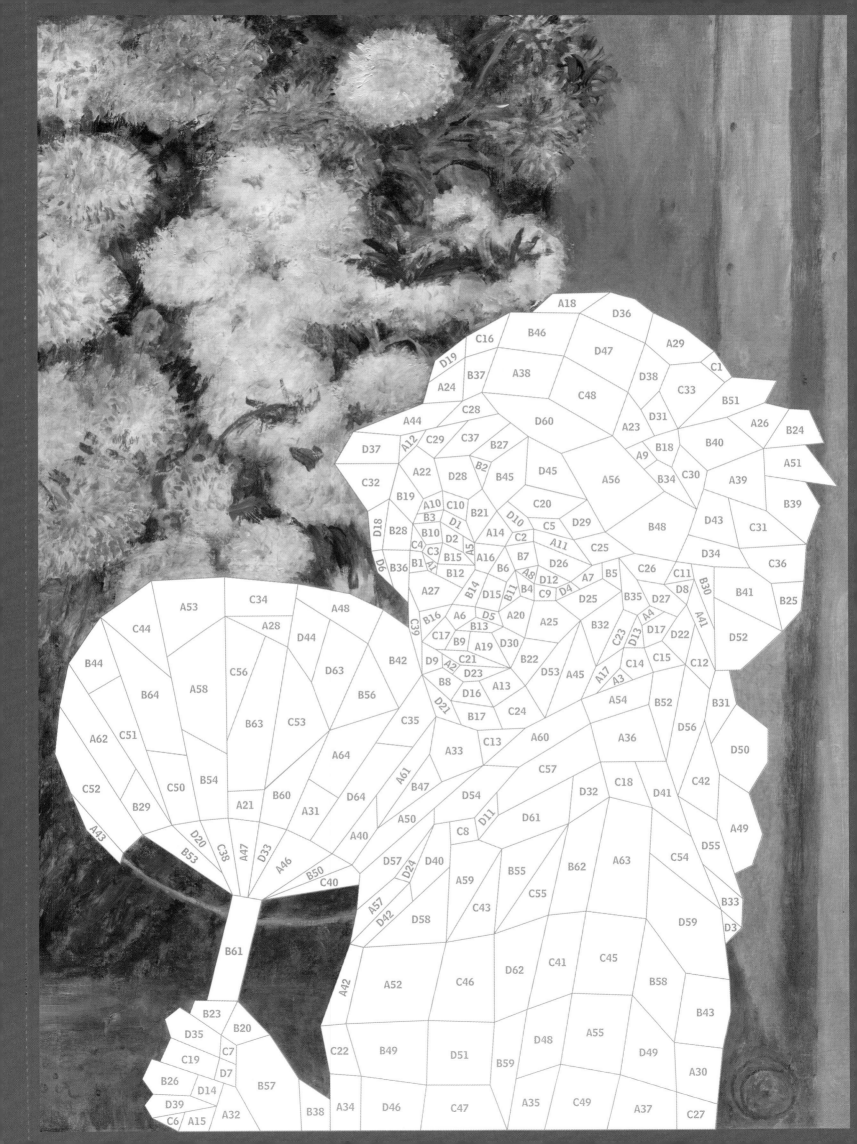

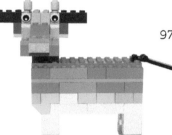

Library of Congress Control Number: 2017947540
ISBN: 9781513260822 (paperback)
9781513260853 (hardbound) | 9781513260846 (e-book)

Designer: Vicki Knapton

Graphic Arts Books
An imprint of

GRAPHIC ARTS
BOOKS®

GraphicArtsBooks.com

Proudly distributed by Ingram Publisher Services.

The following artists hold copyright to their images as indicated:
Barns and Hay, pages 6-7: BlueRingMedia/Shutterstock.com
Farmyard, pages 1, 28-29, front cover (middle), back cover: SkyPics Studio/Shutterstock.com
Stables and Pond, pages 44-45, 58-59, front cover (bottom): MSSA/Shutterstock.com
Henhouse, page 58, front cover (bottom): Spreadthesign/Shutterstock.com

The author thanks the LDraw community for the parts database it makes available, which is used for making instructions found in the book.
For more information on LDraw, please visit ldraw.org.

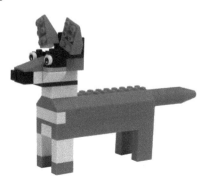

Make sure your Build It! library is complete

 ◯ Volume 1

 ◯ Volume 2

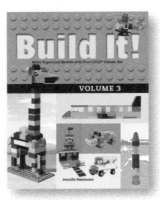 ◯ Volume 3

 ◯ World Landmarks

 ◯ Things that Fly

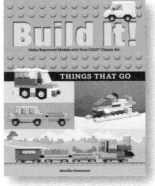 ◯ Things that Go

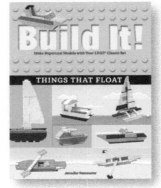 ◯ Things that Float

 ◯ Robots

 ◯ Farm Animals

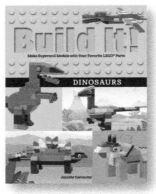 ◯ Dinosaurs

 ◯ Trains

 ◯ Sea Life